For Anita, Matilde, Emma and Sara

www.enchahntedlion.com

First English-language edition published in 2019 by Enchanted Lion Books,
67 West Street, 317A, Brooklyn, NY 11222
Text copyright © 2019 by Paola Quintavalle
Copyright © 2016 by Carlo Gallucci Editore srl, Rome, for the original Italian edition, *Crescendo*
Illustration copyright © 2016 by Alessandro Sanna
All rights reserved under International and Pan-American Copyright Conventions.
A CIP record is on file with the Library of Congress. ISBN 978-1-59270-255-8

Printed in China by RR Donnelley Asia Printing Solutions Ltd.

1 3 5 7 9 10 8 6 4 2

CRESCENDO

Written by
PAOLA QUINTAVALLE

Illustrated by
ALESSANDRO SANNA

ENCHANTED LION BOOKS
NEW YORK

Month 1

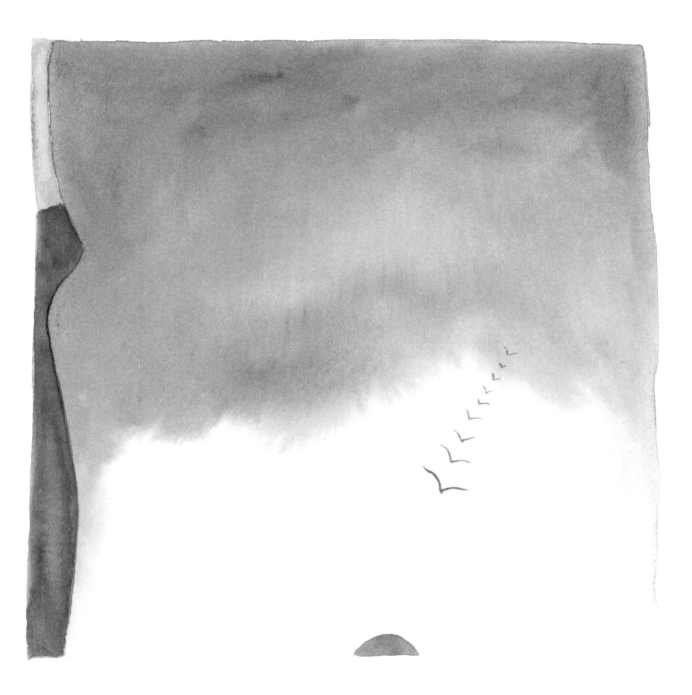

You are as big as a sesame seed

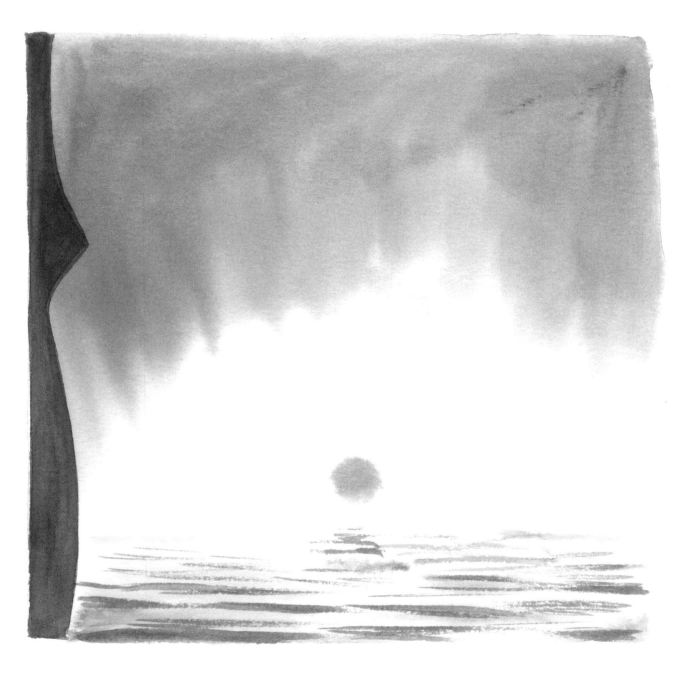

Your heart already trots

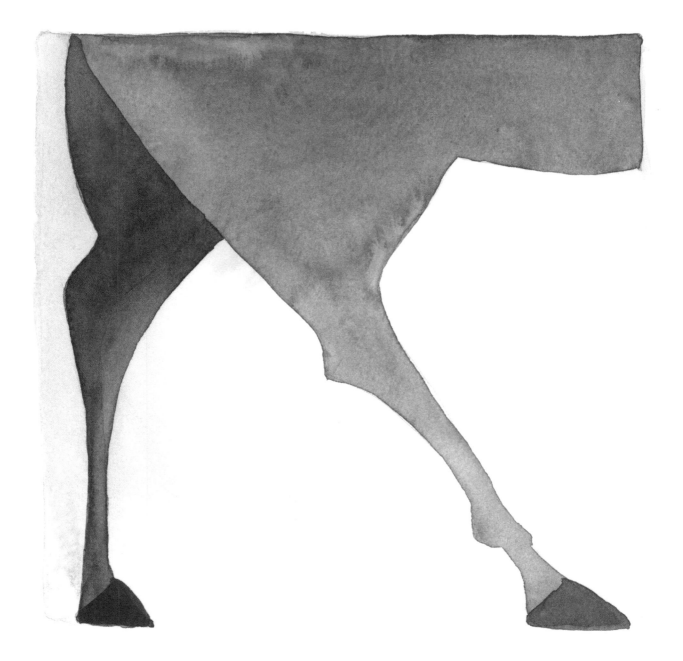

Your wings begin to grow

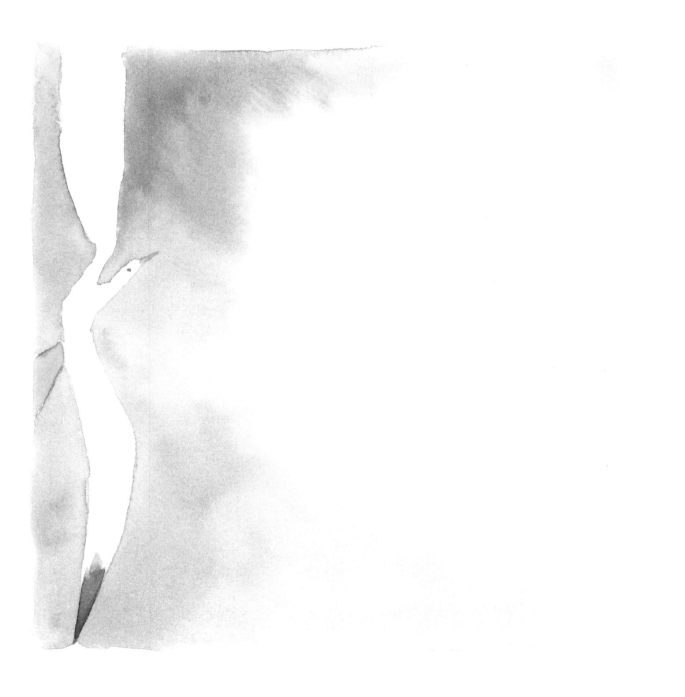

And so do your ears

Month 2

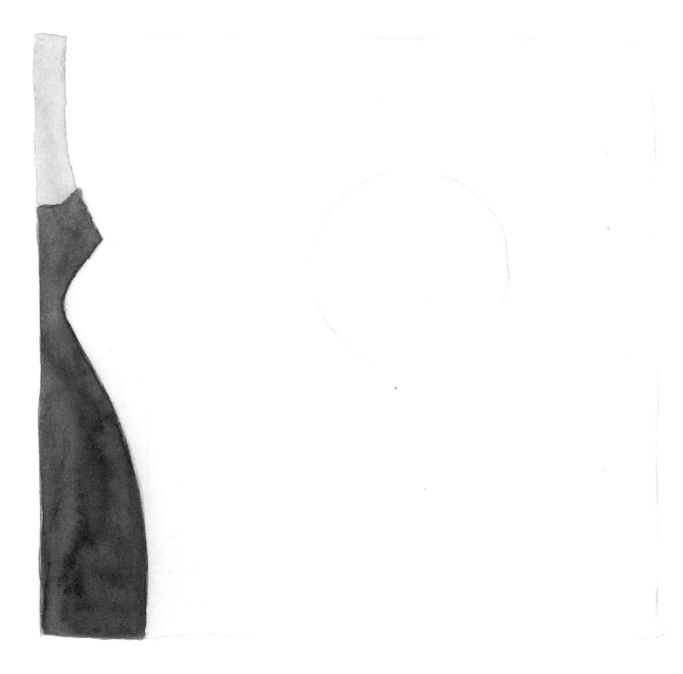

You resemble now who you will become

But do not rush, there's a long way to go

You move in your space, without a sound

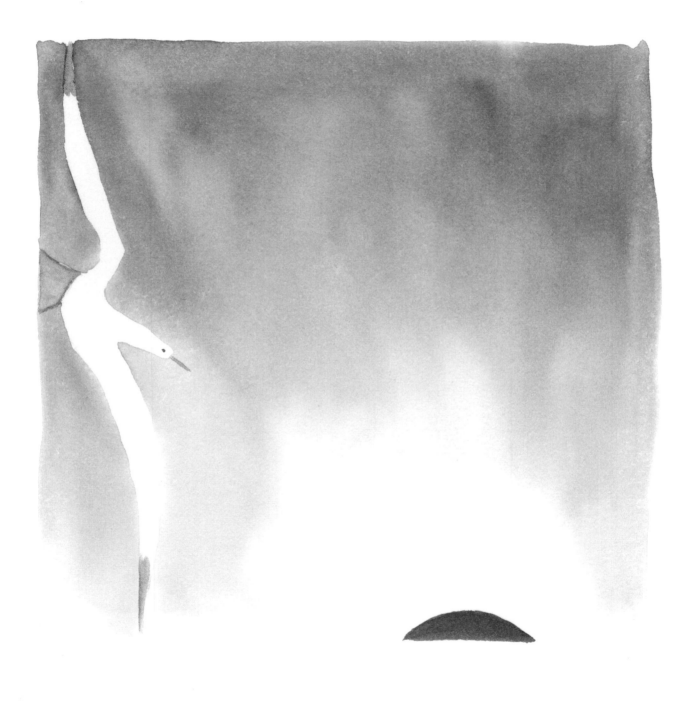

Silently, now and then, a smile

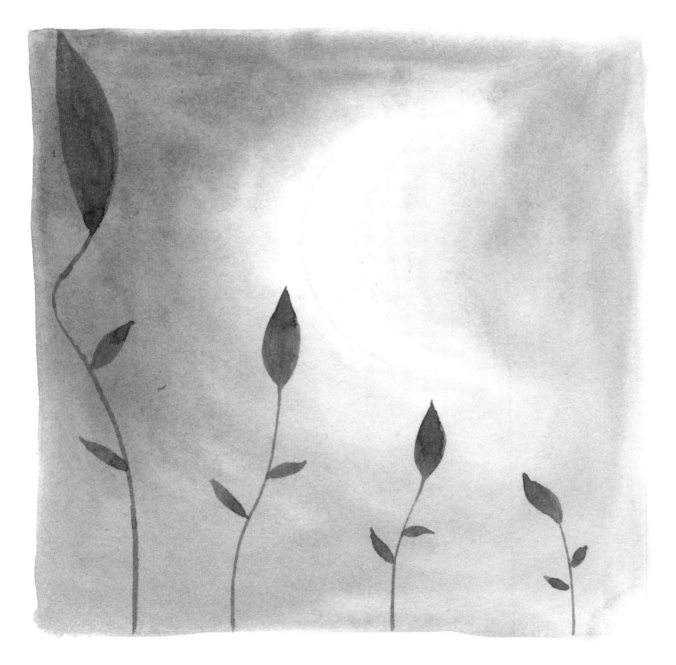

Month 3

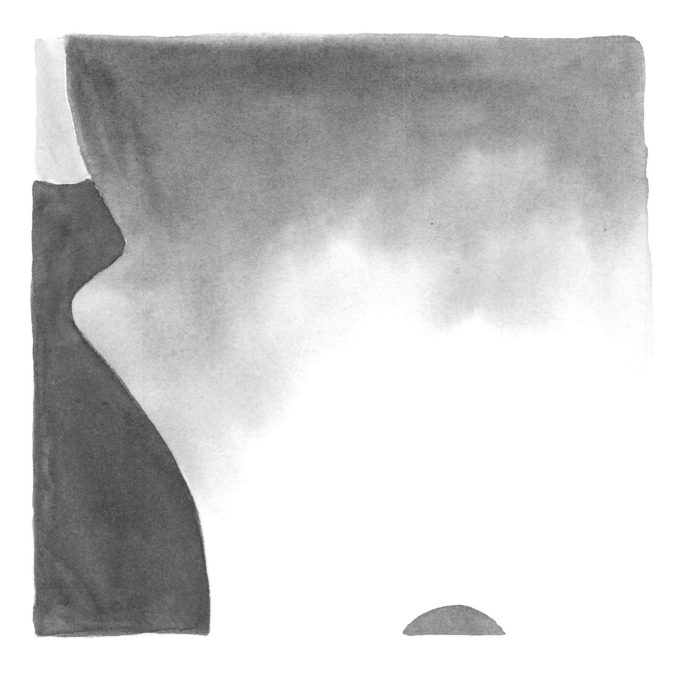

Every day you grow stronger

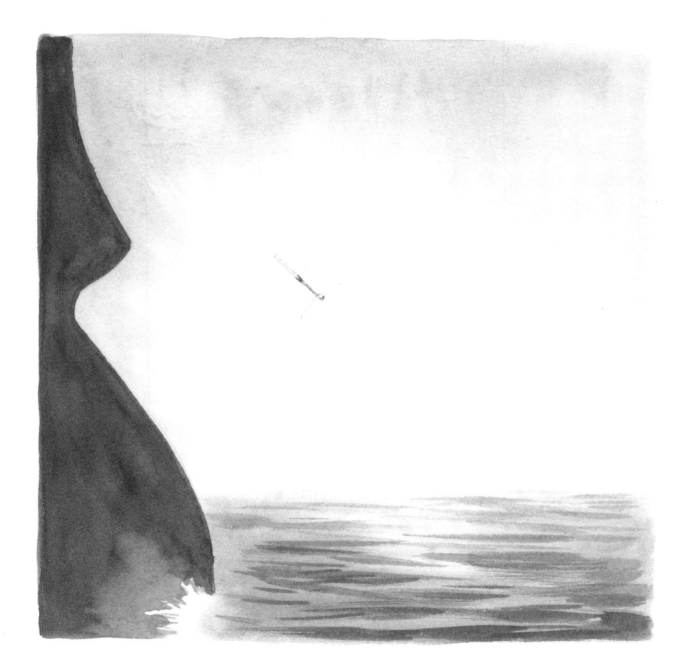

You cannot feel the cold

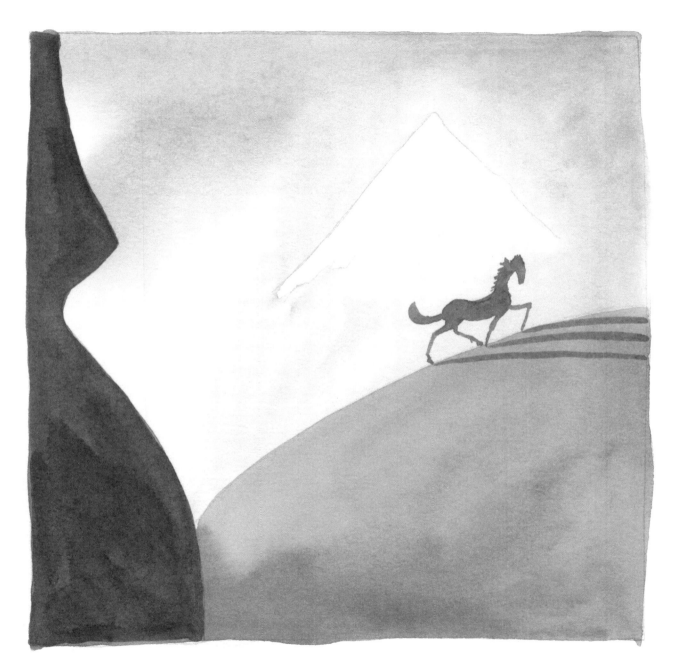

Though you can hear a lullaby

And smell a scent that will one day have a face

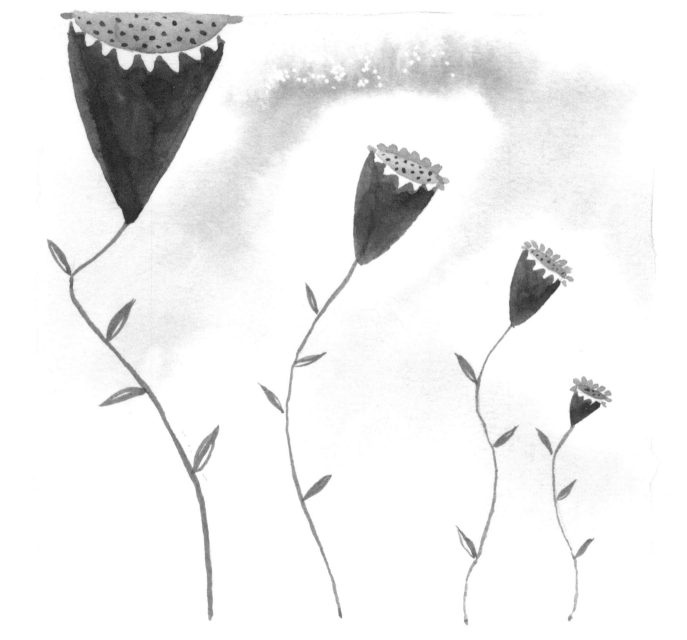

Month 4

Little separates you from beyond

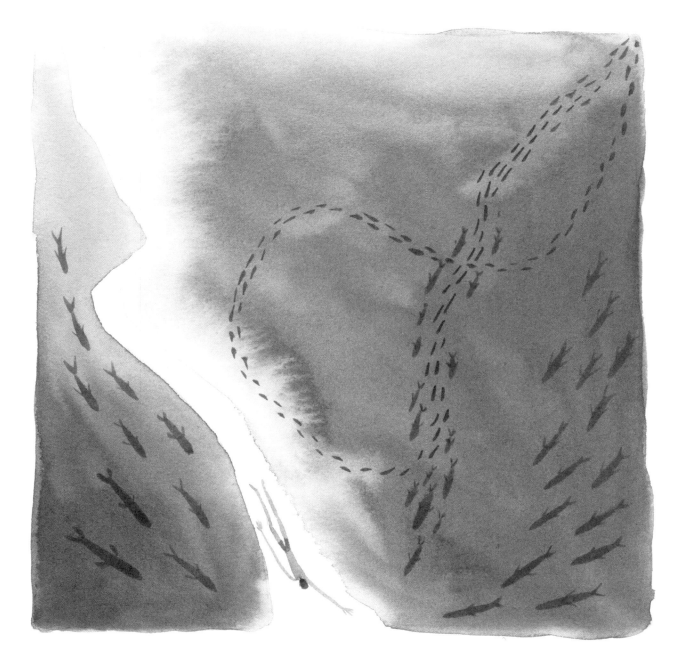

Boy or girl, above all you will be you

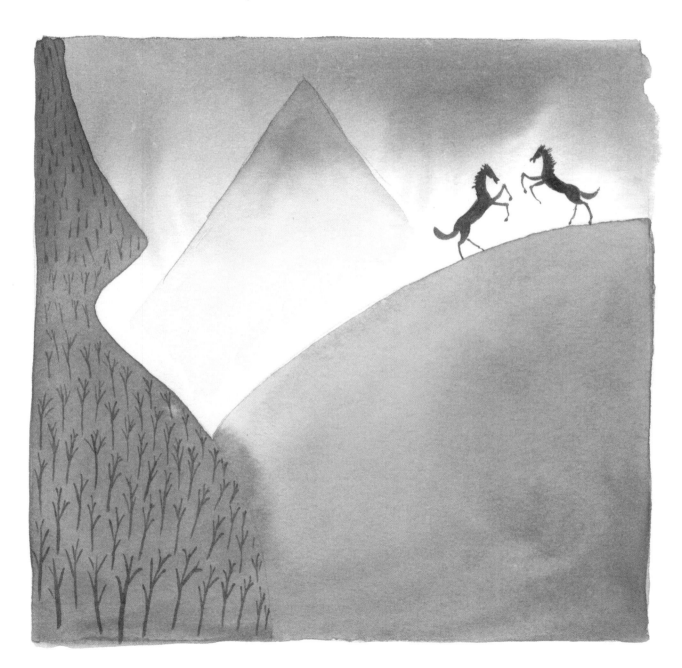

And while you are still learning to breathe

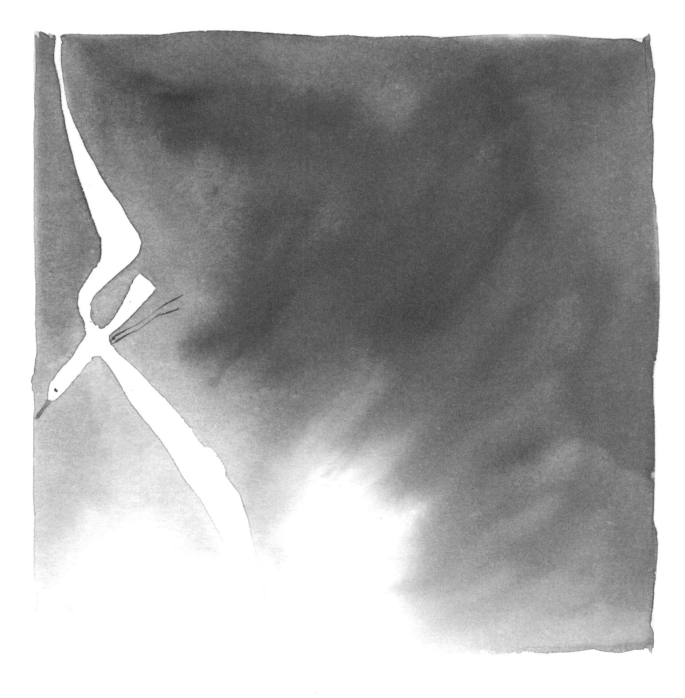

Patterns are drawn on your fingertips for you and you alone

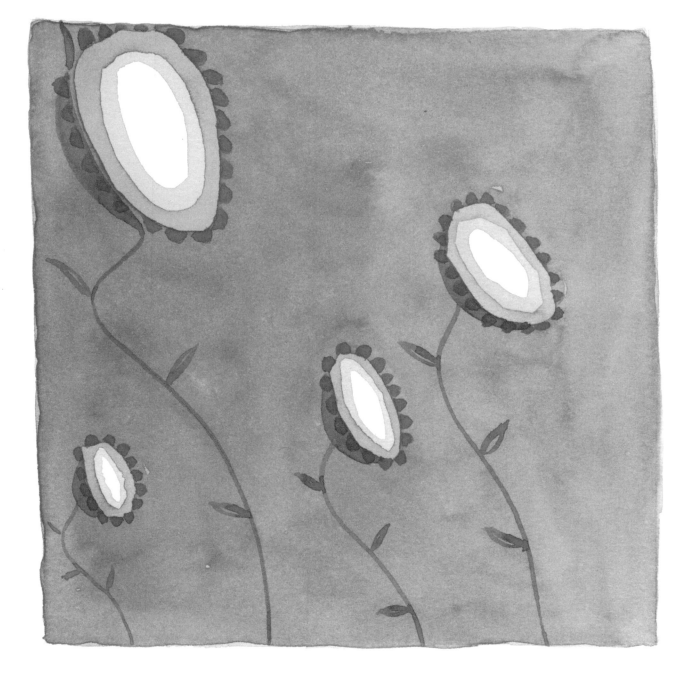

Month 5

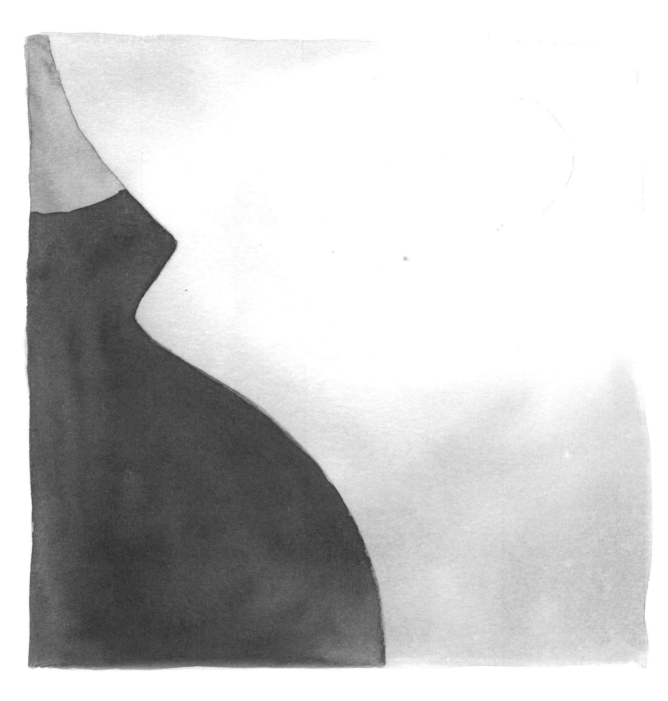

You kick, but it doesn't hurt

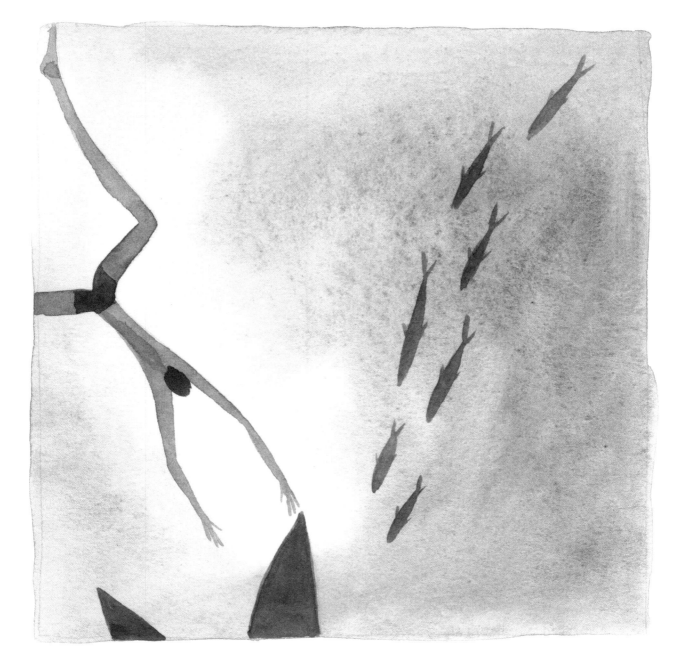

If it's time to sleep, you decide

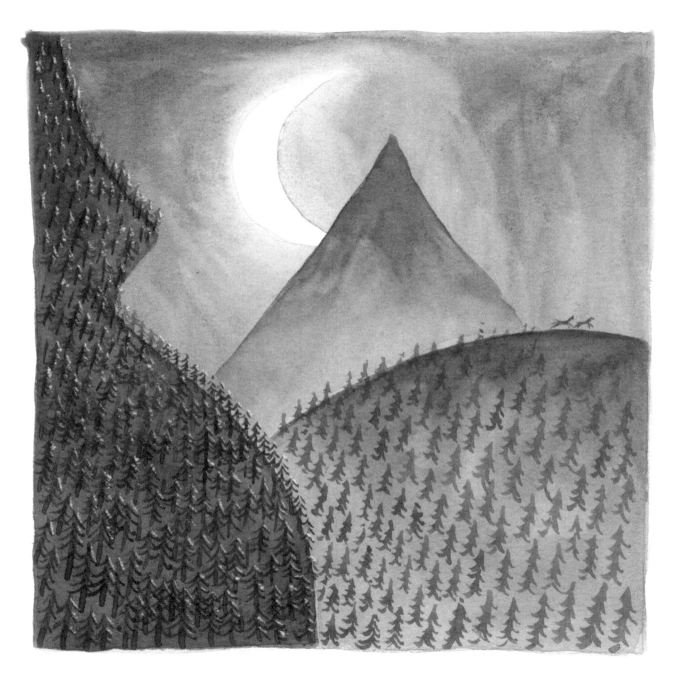

You will soon find your balance

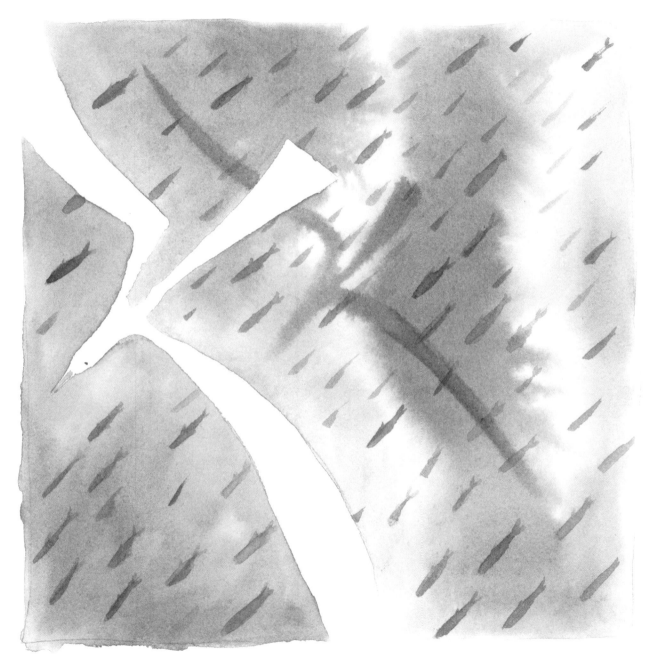

And get to know the world with all its tastes

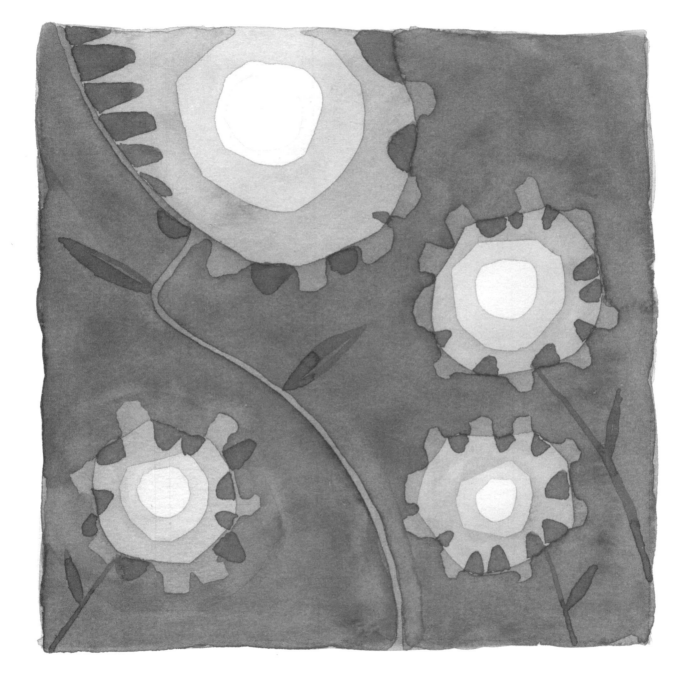

Month 6

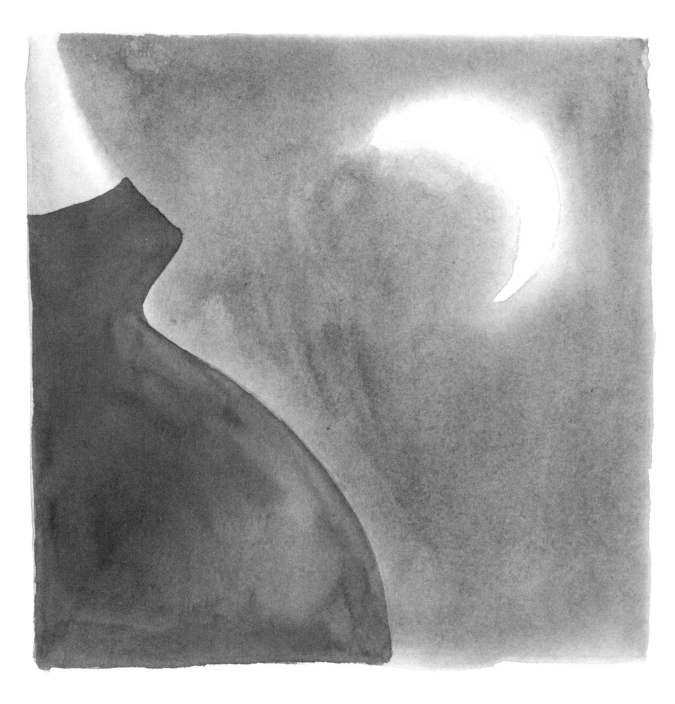

You are learning to cry

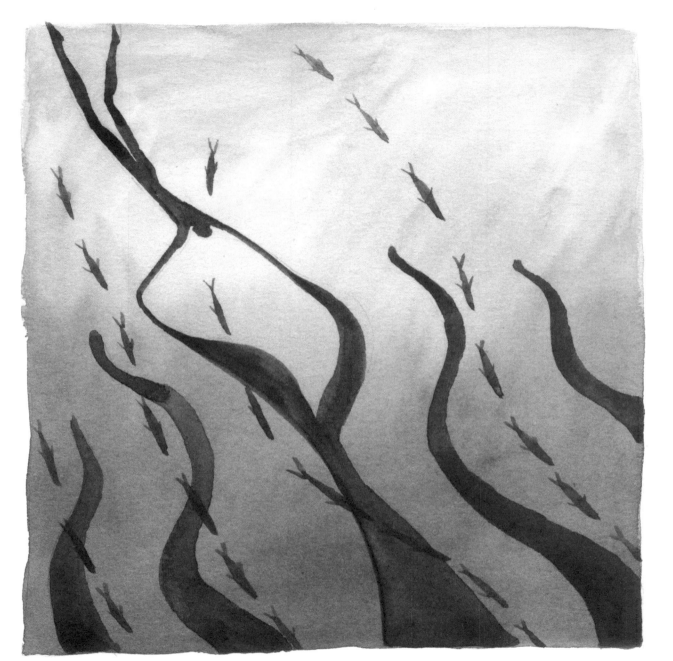

Your eyes conserve the color of the night sky

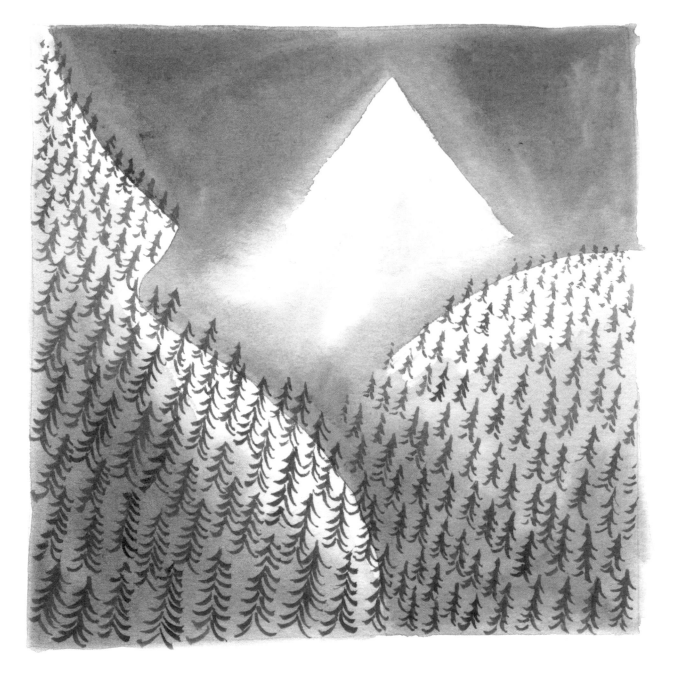

You cannot see, but you sense the light

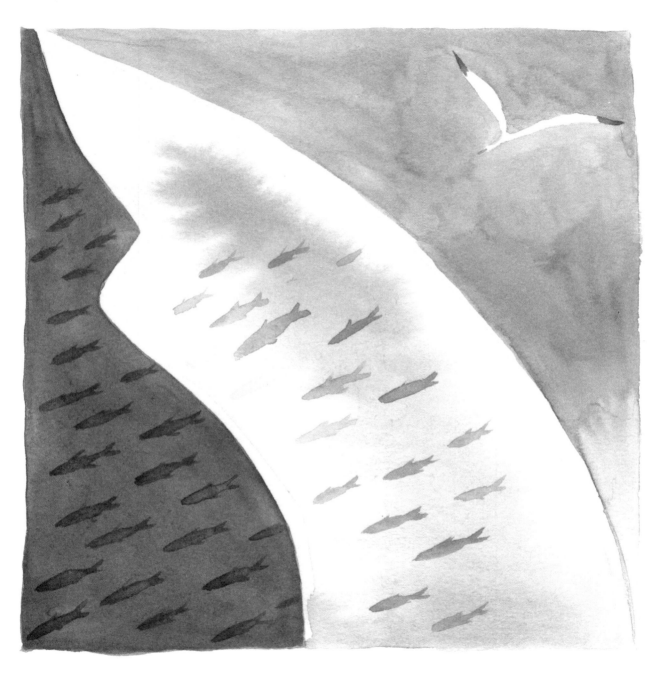

As you turn and tip and tip and turn

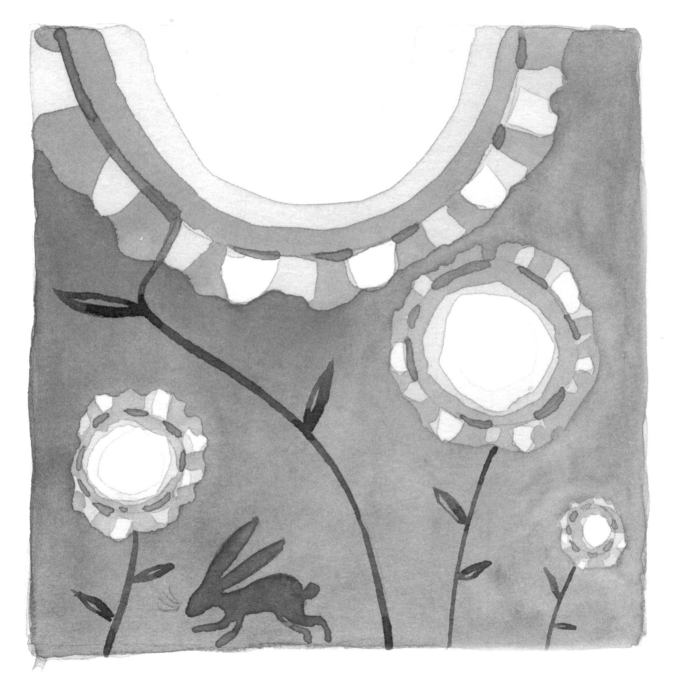

Month 7

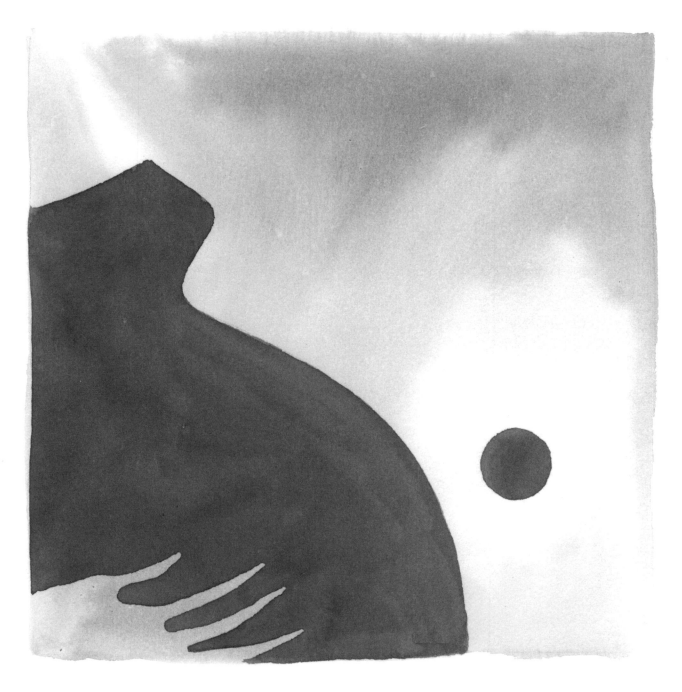

You can think, dream, maybe remember

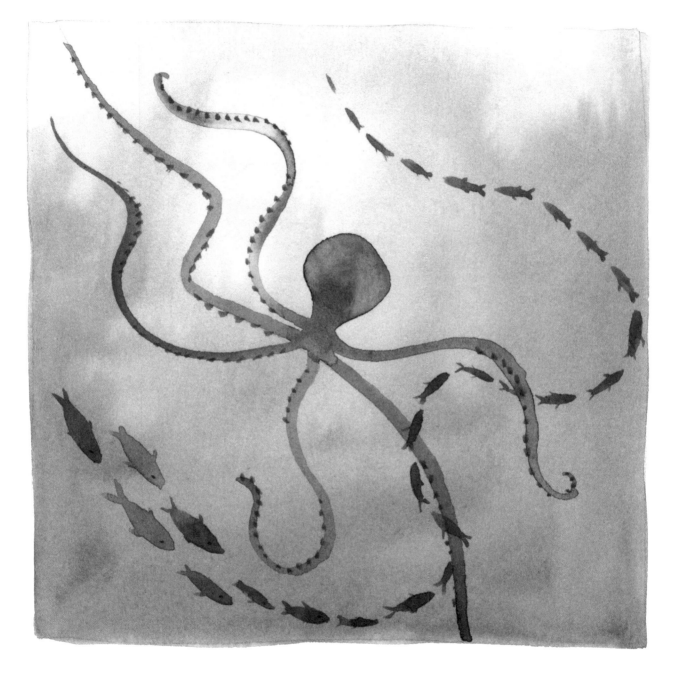

You are sensitive to what's around you

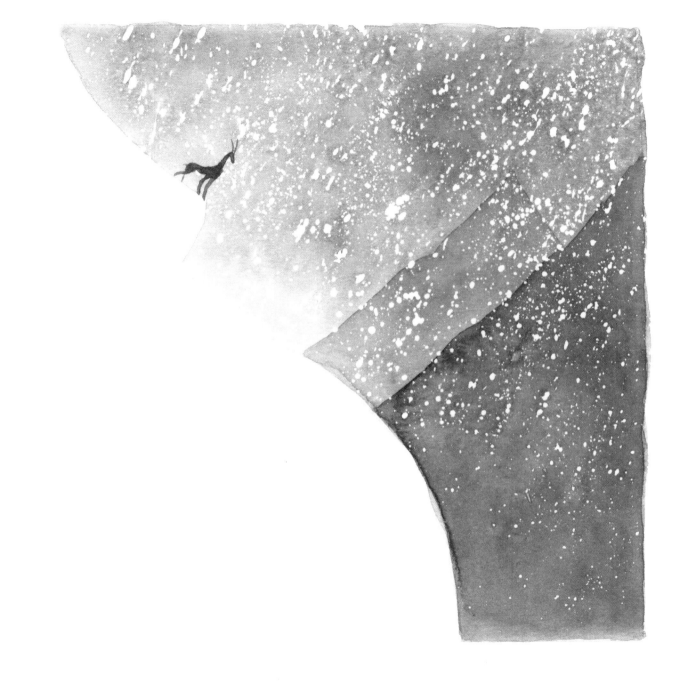

It's not too early for adventure stories

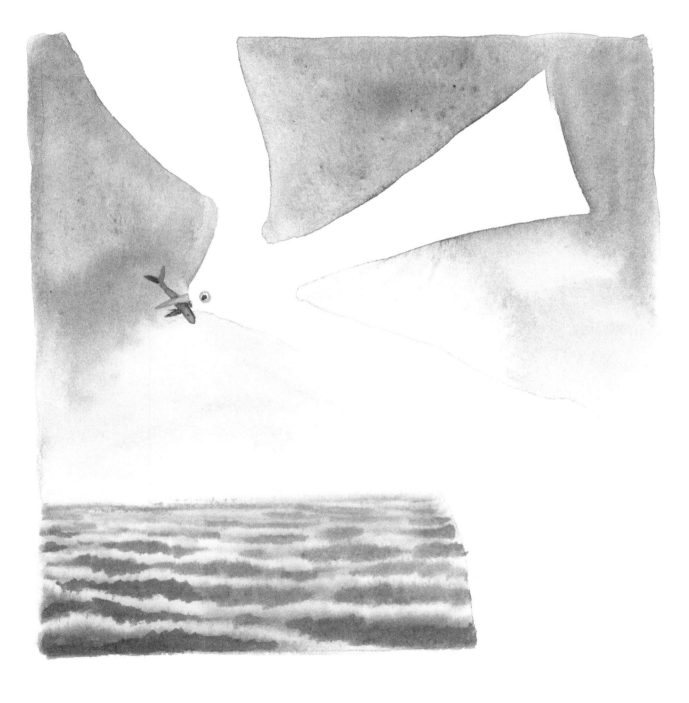

Nor to feel the warmth of a sunny day

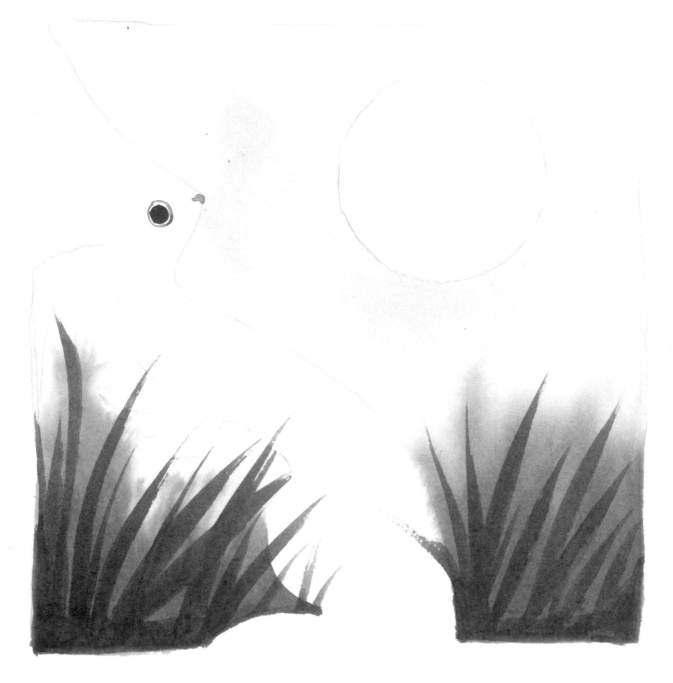

Month 8

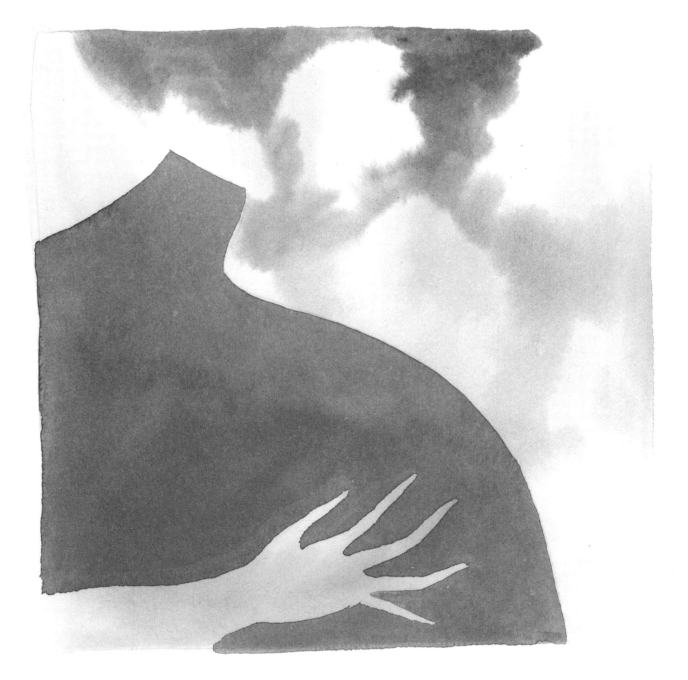

If you are not alone in there

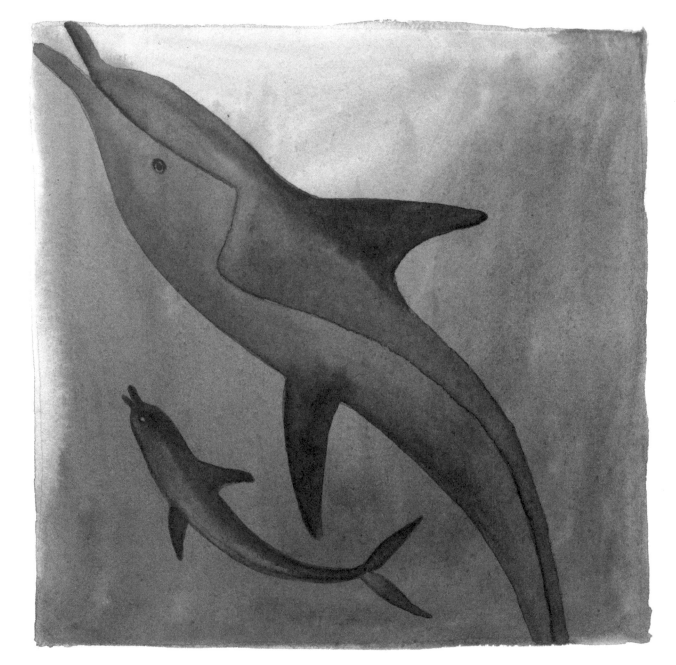

Your arrival may be soon

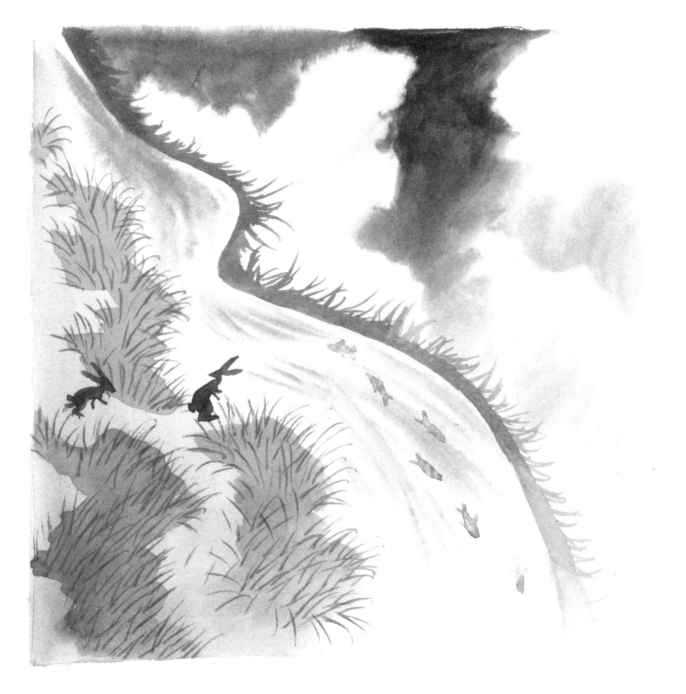

You will bring with you the habit of sharing

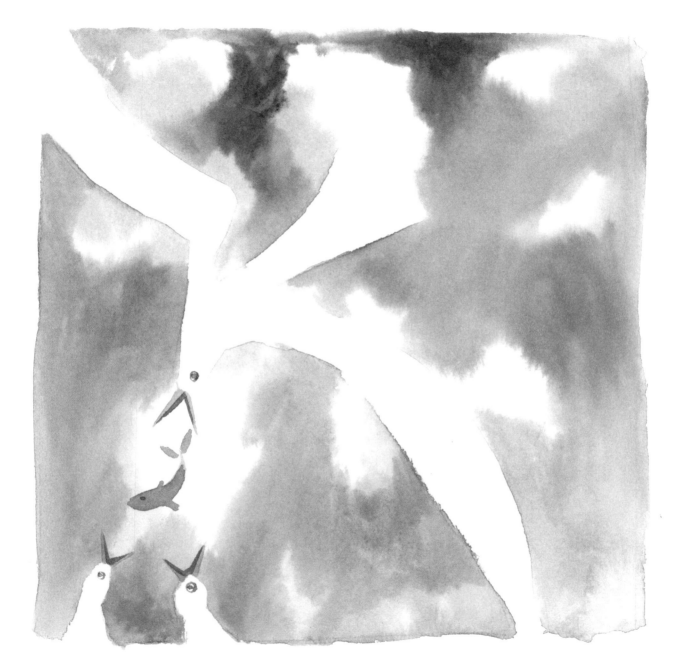

But shine a light that is only yours

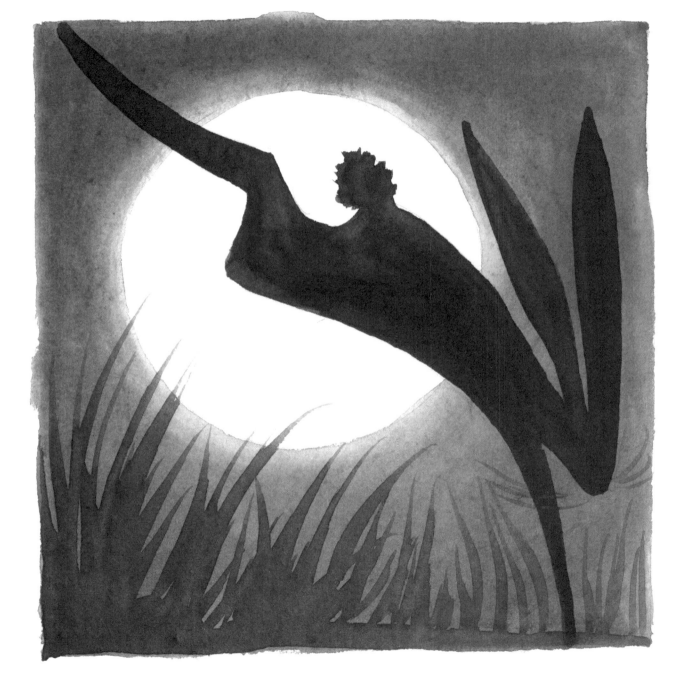

Month 9

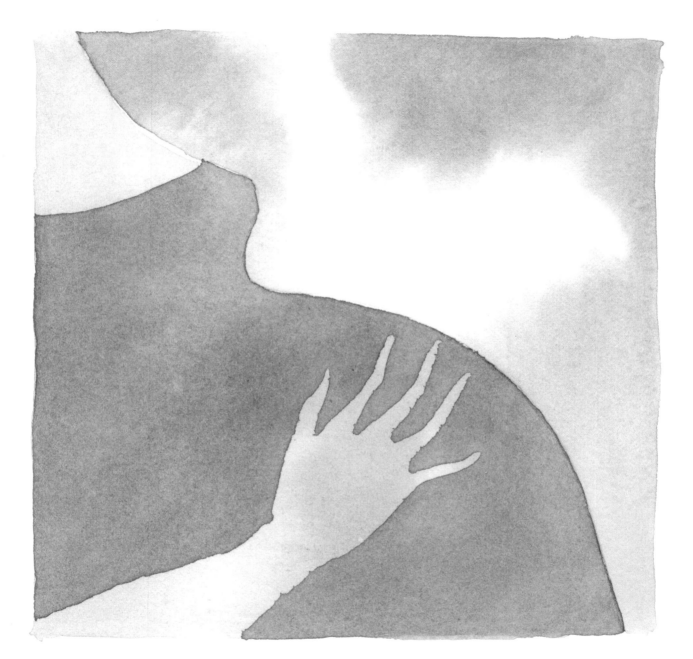

You are nearly at the end of your long journey

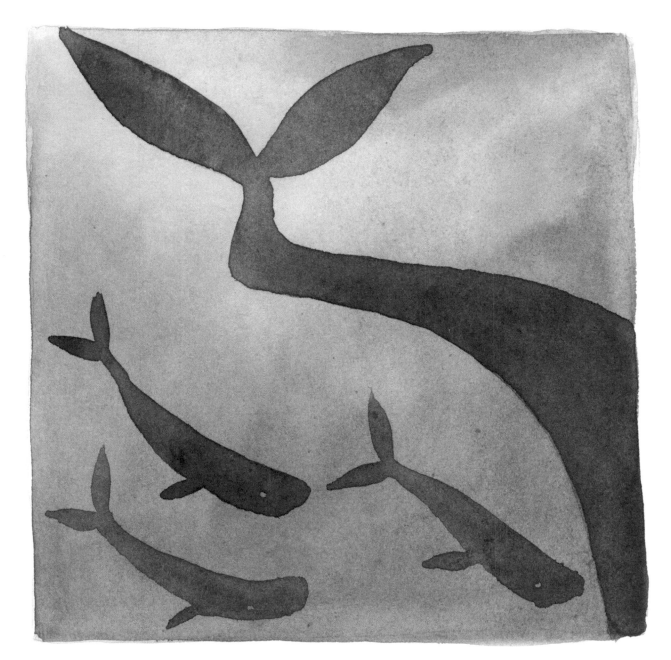

Nine months have almost passed

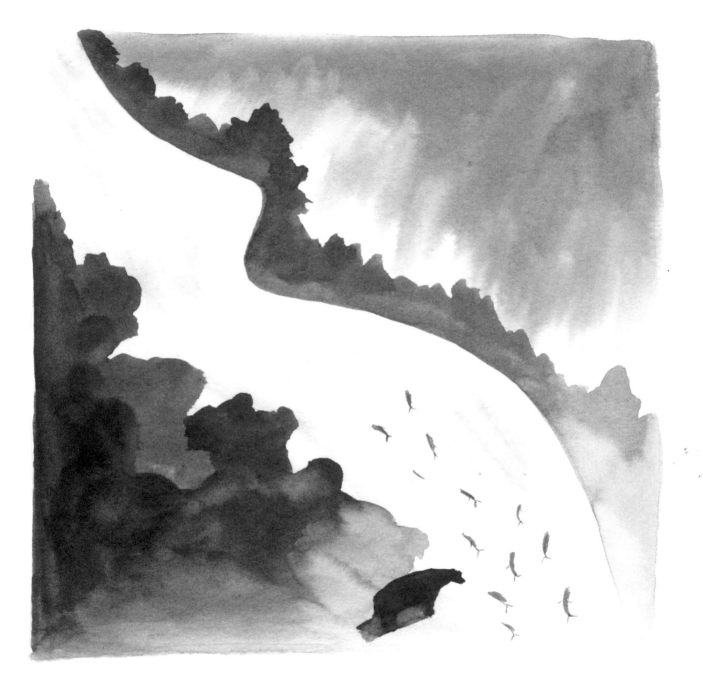

Mother earth is ready to greet you

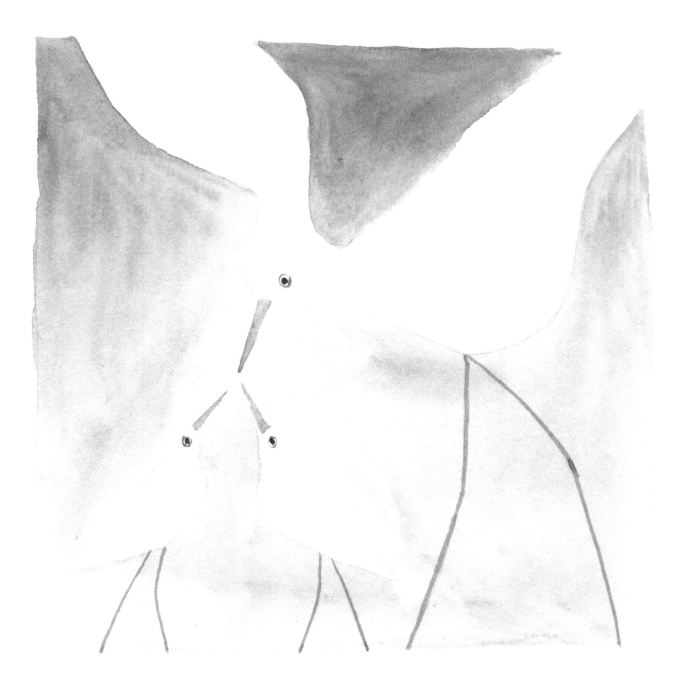

And so am I

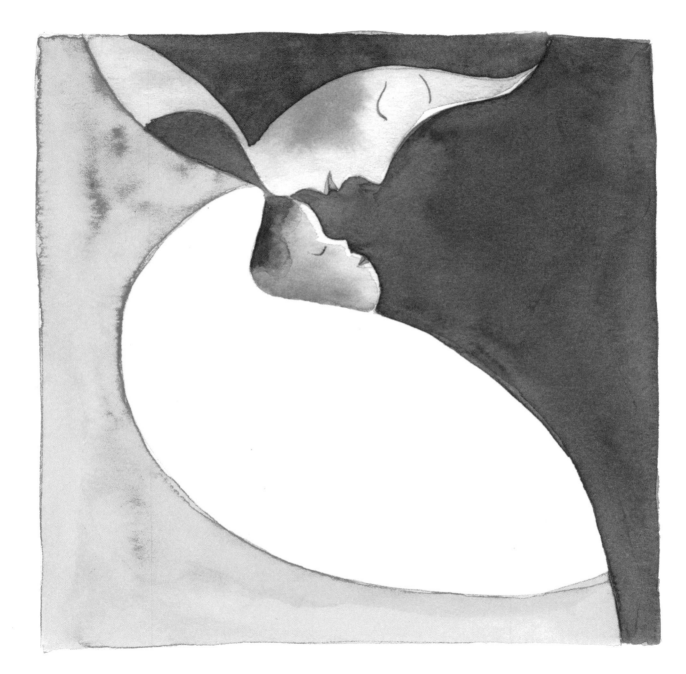

Developmental Facts that Inspired the Text

First month

The baby to be is now an embryo and measures about 0.1 inch. The heart is the first organ to develop and begin to function. Buds, which will grow into arms, begin to sprout and ears start to grow as well.

Second month

The embryo is now called a fetus. It moves freely and has reflexes that can cause facial movements.

Third month

Tiny bones are beginning to form in the arms and the legs. The skin is gradually covered by a thin layer of hair (called lanugo) that helps to keep the fetus warm. The fetus begins to hear sounds and to acquire a sense of smell. Months from now, in the baby's first minutes of life, recalling the scents that it has first smelled inside the womb, can help guide it to its mother's breast.

Fourth month

The fetus is growing within a very thin sac inside the womb. This sac is filled with a liquid called amniotic fluid. The reproductive organs and genitalia can now be seen with an ultrasound. The fetus's lungs are not completely formed yet, but it has started to practice respiratory movements. Fingerprints and footprints are being defined.

Fifth month

Muscles are getting stronger and motor skills are improving. The fetus moves between waking and sleeping states. Its inner ear, which controls balance, is now formed, meaning that it may be able to tell which way is up and which way is down. Its taste buds are now fully developed, and so its sense of taste is improving, too.

Sixth month

With ultrasounds, the fetus can be seen opening its mouth wide, almost like a crying baby, as if it is learning how it will communicate once it is born. The eyes are almost fully formed, but their color will only be conclusively determined during the first months of life, when the pigment melanin, present in all eyes, has had time to react to sunlight and other photostimuli. The fetus is stronger now, and it responds to light and sound with more vigorous and coordinated movements.

Seventh month

As certain senses are developing, so is the capacity to learn and remember. The fetus is more sensitive to light, noise, taste, and smell. Its vision is rather blurry, but it may react with a flutter of activity to bright sources of light like the sun.

Eighth month

Because twins share a single womb, they are typically born by the 37th week of pregnancy. Even when twins are identical, they are unique individuals with distinct personalities.

Ninth month

The fetus is now fully grown and has moved into its birth position. It is ready for life outside of the womb and may be born at any moment during this month.